Deba Foxley Leach

With a Foreword by
Toni Morrison

The **Phillips** Collection
Washington, D.C.

I See You
I See Myself

The Young Life of
Jacob Lawrence

To Jacob Lawrence (1917–2000)

Published on the occasion of the exhibition
Over the Line: The Art and Life of Jacob Lawrence, organized by the Phillips Collection, Washington, D.C.

Published by
The Phillips Collection
1600 Twenty-first Street, NW
Washington, D.C. 20009-1090
www.phillipscollection.org

Library of Congress Cataloging-in-Publication Data
Leach, Deba Foxley
 I see you, I see myself : the young life of Jacob Lawrence / Deba Leach : with a fore-word by Toni Morrison.
 p. cm.
 Retrospective exhibition, May 2001, the Phillips Collection
 Accompanied by art activity handbook titled: The choice is yours / Suzanne Wright.
 ISBN 0-943044-26-X
 1. Lawrence, Jacob, 1917- —Childhood and youth. 2. African American artists—Biography. 3. Art—Study and teaching (Middle school)—Activity programs—United States. I. Wright, Suzanne, 1966- Choice is yours. II. Phillips Collection. III. Title.
N6537.L384 L43 2001
759.13—dc21
[B] 2001021803

Front cover:
Play Street, 1942. Gouache on paper.
30⅞ x 22⅜ in. Mrs. Stacey Clarfield Newman and Dr. Frederic Newman.
Photograph, Jacob Lawrence, age 6, detail (also p. 1).
Photograph, Jacob Lawrence, 1939, detail (also p. 3).

Back cover:
Sidewalk Drawings, 1943. Gouache on paper.
22⅜ x 29½ in. J. Bruce Llewellyn and Shahara Ahmad-Llewellyn.

Book concept: Thora Colot
Book design: John Hubbard
Editors: Johanna Halford-MacLeod and Gail Spilsbury
Produced by Marquand Books, Inc., Seattle
 www.marquand.com
Color separations by iocolor, Seattle
Printed and bound by CS Graphics Pte., Ltd., Singapore

The Phillips Collection thanks ExxonMobil for generously supporting the research, writing, and editing of this book.

I view the content
of **my art** as
autobiographical.

Jacob Lawrence
2000

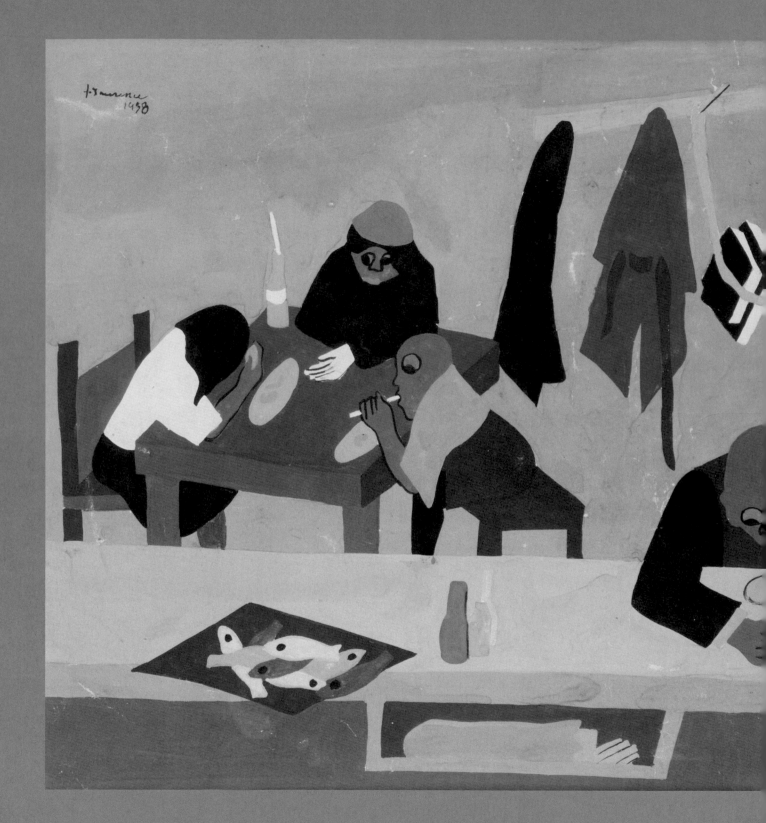

Harlem Diner, 1938

Contents

Foreword

Jacob Lawrence seized beauty—whether it lay in an environment of heartbreak, survival, or triumph. He seized beauty, manhandled it and made us know it, too. He saw the body's music in common labor. In pattern and juxtaposition of color, curve, and line, he translated intricate activities and gestures of lyric simplicity into revelation, into rapture. No romance leaps from his canvases to seduce us. No easy sentiment drips from his brush. The brilliance, the precision of his works are clear, up-front, assertive, brooking no debate, making no plea. Since his 1938 Harlem YMCA exhibit and the Rosenwald awards that followed in the early 1940s, on through some sixty years of hard, rich work, generations of painters have been in thrall to him. And thousands of us remain lit in his burning glare.

Toni **Morrison**

Introduction

Jacob Armstead Lawrence (1917–2000) was a painter and a storyteller. The color patterns in his paintings are so beautiful and so clear that people have never forgotten the hard truths his artwork and stories reveal. Jacob Lawrence often depicted historical themes that ranged from the Civil War period to the civil rights movement of the 1960s, when the United States' hope for freedom and justice clashed with harsh economic and social realities. Yet Lawrence never called himself a history painter. If his work had to be compared to anything, Lawrence said it should be compared to "a portrait of myself, a portrait of my community." By confronting and embracing the black experience in his cycle of sixty paintings entitled *The Migration Series* (1941), Lawrence achieved interracial and national acclaim early in his career. And he never stopped exploring his identity.

Jacob Lawrence's outstanding career lasted more than sixty-five years. Six weeks before his death, ill with cancer, Lawrence was still making drawings in preparation for his next cycle of paintings. The theme would be universities.

Jacob Lawrence often talked about how he became an artist. He called himself a child of the Great Migration. He was born in Atlantic City, New Jersey, to parents on the move from South Carolina and Virginia. After several years living in and out of foster homes in Philadelphia, Lawrence formed deep roots in the Harlem community, where he came to live with his mother at age thirteen. This was also the year he began to paint. Lawrence's formal and informal education was picked up within Harlem's community art workshops and on the streets. No subject—not the iceman or the storefront church, not the pool hall or the latest political movement—was too small or too overwhelming to escape the boy's keen eyes and ability to understand.

Jacob Lawrence's first art teacher, Charles Alston, encouraged him to see and express the geometric structures and patterns present in everyday life, from the decor of his family's apartment to the streets, facades, and storefronts of Harlem. His mother's quilts were perfect examples to study. Step-by-step, Lawrence came to recognize his own voice and began to invent a language of shapes and colors. By mastering the abstract rhythms of composition, he took command of the picture plane. He was ready to be the architect of his own observations and a designer of visual experiences that others could share.

Perhaps it was the Great Depression that quickened Lawrence's conscience about the harsh world around him. It may have been the idea of doing more with less that challenged him to express his unique vision. Whatever the complex array of influences on the young artist, he ascribed meaning and value to his continued use of only three tempera colors. His work became stronger using fewer colors. He saw that changing one color or shifting only one shape made his picture rhythms seem precise and necessary.

Lacking the age and experience to get a commission to paint a public art project, such as a mural, Lawrence devised a way to tell his stories without a wall, in the alternating rhythms of highly portable, hardboard panels. By age twenty-one, he had chronicled the lives of Toussaint L'Ouverture, Frederick Douglass, and Harriet Tubman at a time when African-American history was practically invisible to most people. Retelling these stories of struggle opened his understanding to greater depths, just as opposition of colors brought tension and life to his paintings. At the heart of Lawrence's inventions lives a deep truth; he himself spoke of it: "My belief is that it is most important for an artist to develop an approach and philosophy about life—if he has developed this philosophy he does not put paint on canvas, he puts himself on canvas."

Elizabeth Hutton **Turner**
Senior Curator
The Phillips Collection

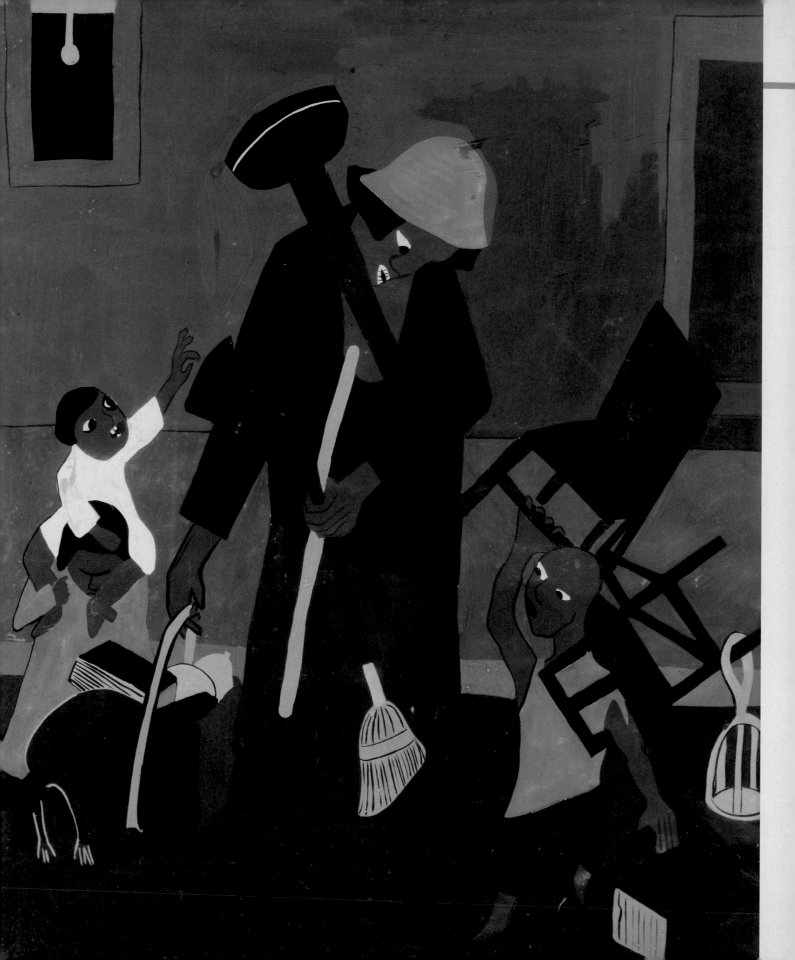

Most people move at one time or another in their lives. Moving can bring positive feelings of excitement, anticipation, and discovery. Moving can also cause pain. People who move feel separated from the people and places they knew. And on top of that, trying to fit in can be a full-time job.

The experience of moving was important to the artist Jacob Lawrence. By the time he was thirteen, he had lived in three different states—New Jersey, Pennsylvania, and New York—and with several foster families. Jacob Lawrence coped with his many moves by becoming more aware of his surroundings. He was especially good at remembering places he had left behind. He remembered past scenery as vividly as the new, contrasting his new homes with memories of the old ones.

Jacob Lawrence was born in Atlantic City, New Jersey, on September 7, 1917, to parents who were on the move. His father, Jacob, had moved north from South Carolina and his mother, Rosa, from Virginia. The couple met and married in Atlantic City, New Jersey. Jacob Lawrence Sr. was a cook for the railroad, which meant he often was away from home. Rosa, a domestic worker, had to move around to find jobs. When young Jacob was two, the family moved from Atlantic City's seacoast to the hills of Easton, Pennsylvania. This industrial town's iron and stone railroad bridges and crisscrossing tracks may have been imprinted on the young artist's mind.

One of Lawrence's earliest memories was of falling down a hill in Easton. Late in life, he could still see the scar on his leg from the fall. "It was a small thing but traumatic at the time," he said. It was a moment when surprise, pain, and the way things looked around him became fixed in his memory. Perhaps he remembered sprawling on the sidewalk and seeing the angle of land meeting sky—a tipped horizon.

opposite:
Dispossessed, 1937

11

When Lawrence was seven, his parents separated and his mother moved to Philadelphia with the three children—Jacob, Geraldine, and William. For the next five years, the children moved in and out of different homes, sometimes living with foster families. For three of those years, Jacob's mother lived in Harlem, New York, searching for work that would enable her to reunite the family. During that difficult time, she would often return to Philadelphia to visit the children.

Lawrence recalled the streets, backyards, and empty lots in Philadelphia. One can imagine how he walked along a row of townhouses, "brownstones," as he called them, feeling grounded—visually and physically—knowing his neighborhood. Was this his first memory of urban shapes, architectural forms, and contrasting colors? Lawrence remembered, "I was about ten and in Philadelphia when I first became aware of color." His response to rows of bricks set against a bright blue sky or to a backyard's vivid green growing against the brown fences—did these colors and shapes inspire his art? According to Lawrence, "Color may have one meaning for you and one meaning for me."

Lawrence responded to and recalled the sights of Philadelphia and its people. He often heard the words "another family is coming up." Then he would watch as a family arrived from somewhere "down South." His foster parents would help the newcomers, providing them with warm clothes and chunks of coal for heat. The new arrivals were unaccustomed to cold weather and city life. They came by train, weighted down by bags. They settled in and sometimes, like Lawrence's family, they packed up and moved on again. Perhaps because this scene was so familiar, Lawrence considered his family's situation no different from others he knew or observed: change and struggle were part of life.

Later, as he read history books at the Schomburg Library in Harlem, Lawrence learned that he was born during a period when tens of thousands of black families moved north in search of better jobs, housing, schools, and fairer treatment. Lawrence's mother and father were part of this "Great Migration"; Lawrence, too, was part of the struggle, the movement toward a better life.

By the time Lawrence joined his mother in Harlem in 1930, he had already experienced many disruptions in his life—numerous moves, the separation of his parents, foster homes, and his family's relocation to Harlem. He also discovered something—an awareness of space and color and an empathy for the lives of the people around him. The groundwork was laid for telling their stories—his story—later on in his art.

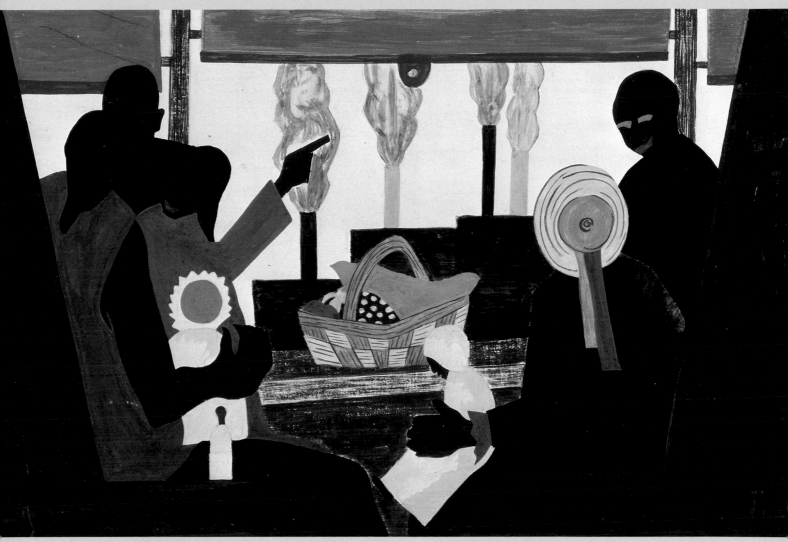

The Migration Series, 1941, panel 45

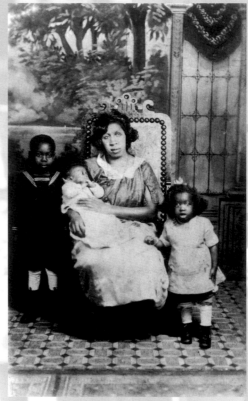

Jacob Lawrence, age six, with his mother Rosa Lee Armstead Lawrence, his brother William Hale, and his sister Geraldine, 1923.

1917–30 Birth to Age 13
Remembering *Moving*
Awareness

1917: born
Atlantic City, New Jersey

1919: age 2
moves with parents to
Easton, Pennsylvania

1924: age 7
moves with mother to Philadelphia

background:
Unknown mother and child
on New York street, late 1920s.

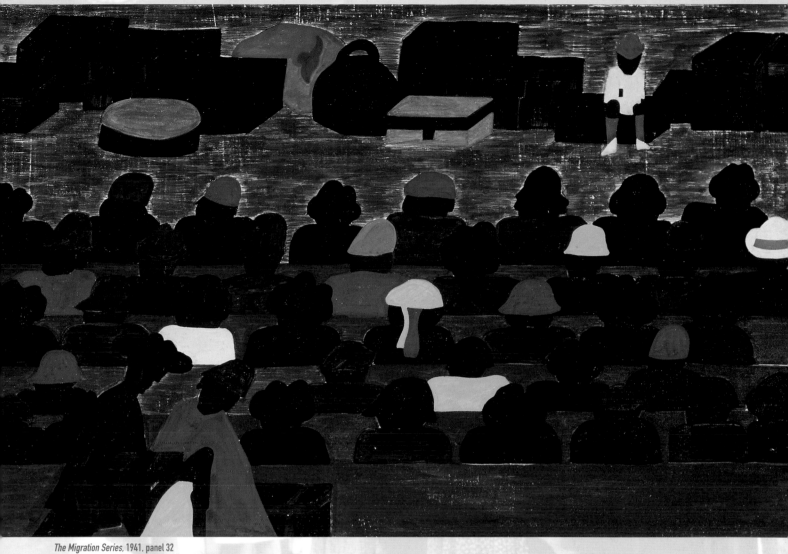

The Migration Series, 1941, panel 32

1927: age 10
mother moves to New York City

1930: age 13
mother brings Jacob, Geraldine, and William to Harlem

Scared

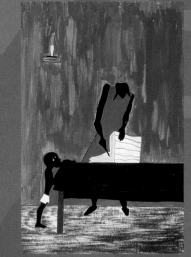

The Migration Series, 1941, panel 11

Hungry

Remem

The Harriet Tubman Series, 1939—40, panel 6

Moving

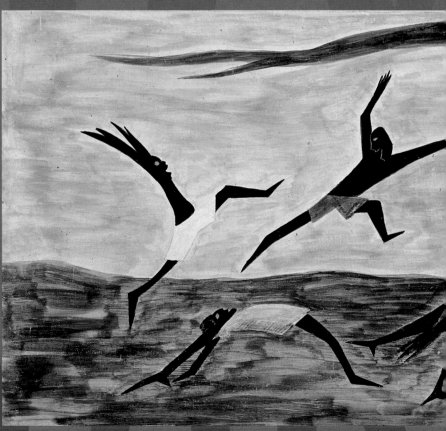

The Harriet Tubman Series, 1939—40, panel 4

The Migration Series, 1941, panel 47

BRINGING

Hope

The Migration Series, 1941, panel 33

Leaving

ering

Awareness

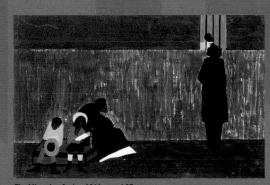

The Migration Series, 1941, panel 27

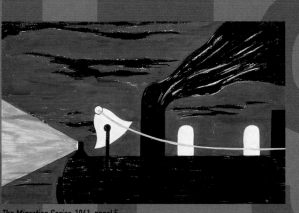

The Migration Series, 1941, panel 5

Going

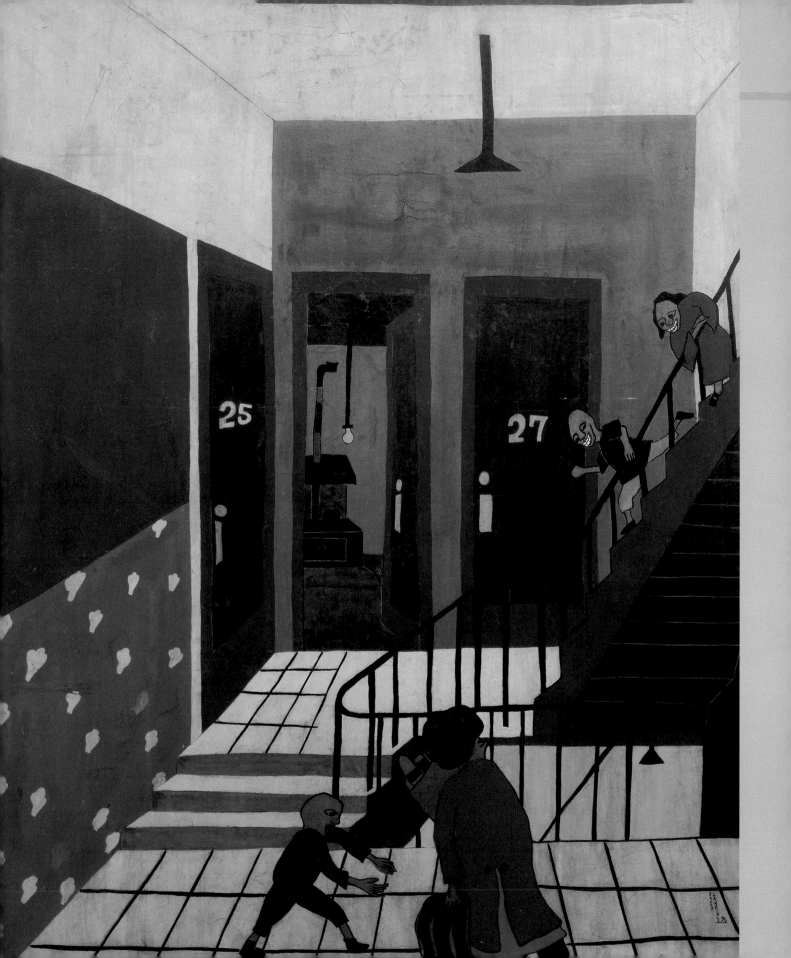

Harlem

Discovery

Identity

In 1930, at the time of the Great Depression, Jacob Lawrence, his brother, and his sister moved to Harlem. They lived with their mother in an apartment on West 143rd Street. Rosa Lawrence managed the household, took the children to church (three times a week), and made sure they went to school. Jacob, now thirteen and the oldest, was the man of the house. Although his father, also named Jacob, had moved to Harlem, too, he did not live with the family. Young Jacob saw his father from time to time at the corner grocery store where he worked.

With the fresh eyes of a new arrival, young Lawrence took everything in. First he noticed the tall buildings, taller than Philadelphia's "brownstones"—so tall he couldn't see the tops. He was amazed to find children playing marbles in the gutter, chasing each other on the rooftops, and swinging from the fire escapes.

Harlem's streets were full of activity. Diners, storefront churches, pool halls, and street vendors were open all day and all night. Walking the streets, young Lawrence saw a parade of costumes, heard a chorus of different languages, and smelled foods cooked in a variety of oils and spices. His many new neighbors were Protestant, Catholic, Muslim, and Jewish. They came to Harlem from the South, the Caribbean islands, and Africa.

Rosa Lawrence belonged to the Abyssinian Baptist Church, a strong congregation in Jacob's new community. It was here that Lawrence and other children heard the famous minister Adam Clayton Powell Sr. preach the "Dry Bones" sermon about a vision from the Prophet Ezekiel. The images and the lesson from this story were vivid. Ezekiel saw that faith can bring hope, just as God had brought life to a valley of dry bones. Lawrence learned that such a story from the Bible—a story told and retold—had power. It strengthened people to surmount their problems. Such stories offered hope that even poverty and prejudice could be overcome. As Lawrence said, "In the Harlem community . . . people were desperately poor . . . but there was always a feeling of hope, a feeling of encouragement."

opposite:
The Homecoming, 1936

Rosa Lawrence worked all day and sometimes into the night. While she worked, she needed to know her children were safe. Lawrence said that it was probably through the church that his mother found Utopia Children's House to look after her children. Utopia House, located on West 130th Street about one mile from Lawrence's home, was one of several neighborhood centers in Harlem. Run by African-American women to help other working women, Utopia House offered day-care services and instruction in sewing, arts and crafts, and sports. For a small fee, preschool children could be left there during the day, and school-goers like Lawrence could go there after school. For his first activity at Utopia House, Lawrence chose arts and crafts.

Art classes were offered at centers like Utopia House because of the 1920s movement known as the Harlem Renaissance. During this period of great artistic activity by African Americans, their unique story was told in poetry, fiction, nonfiction, and the other arts. Lawrence's art teacher at Utopia House, Charles "Spinky" Alston, was part of the Harlem Renaissance. At the same time that Alston was learning to teach art at the Columbia University Teachers College near Harlem, Lawrence was learning from Alston how to make art. Alston was both teacher and mentor to his young protégé. He was a man whose voice and manner said it was okay to choose art.

In keeping with the spirit of the Harlem Renaissance and the most up-to-date way of teaching art, Alston encouraged his students to express themselves freely. He showed Lawrence the basics of painting with poster paints, drawing with pencils and crayons, and working with clay and metal. "I immediately liked making things in clay and playing with color," Lawrence later said.

At Utopia House, Lawrence was urged to see art everywhere he looked. If he saw a design in a rug or a piece of fabric at home, he was prompted to use it as a starting point for making designs of his own. Lawrence later recalled that his mother and her friends furnished their homes with bright colors; he wondered if the warm, bright colors had been chosen on purpose to take the edge off the cold, sad gray of the Depression.

With the sensitivity of a great teacher, Alston encouraged Lawrence's interests and choices. When the boy showed curiosity in a book about African masks, Alston suggested making his own mask in papier-mâché. In his free time Lawrence would create small scenes out of discarded cardboard boxes, standing them up like stage sets with painted cardboard figures inside. When he couldn't find materials at home or on the street, he bought them at the five-and-dime store. People at his church also noticed his work and gave him a prize for a painting that mapped the journeys of St. Paul.

None of Lawrence's earliest drawings, paintings, or sculptures has survived, but the good memories of his first year in Harlem, especially the art classes at Utopia House, stayed with him. The after-school program provided structure in his life. Under the kindly eye of his mentor Charles Alston, he created his own form of self-expression. Lawrence found joy in telling stories with pure colors and strong shapes. As he later said, "I didn't even realize it was art at the time. I just did it because it was fun."

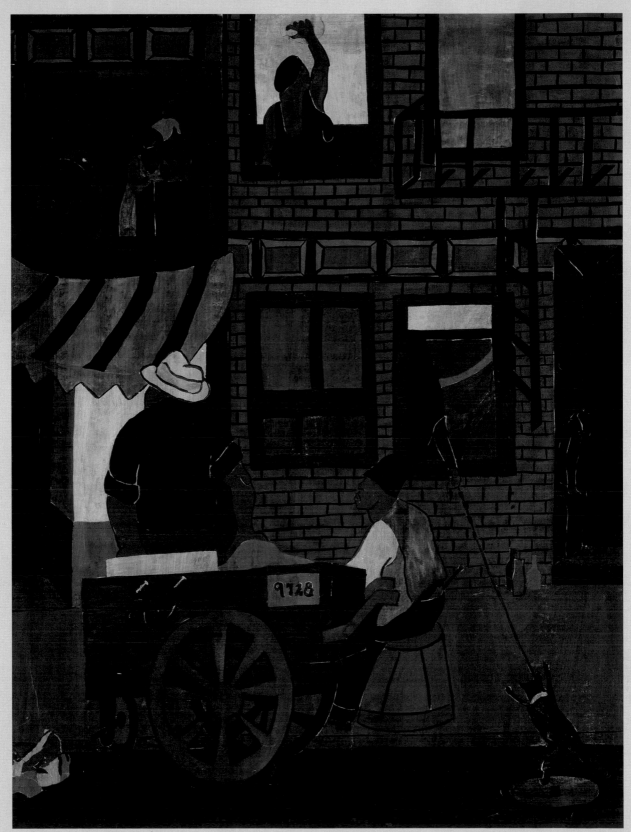

Ice Peddlers, 1936

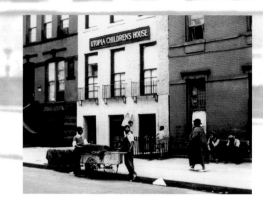

Utopia Children's
House, Harlem,
summer 1938.

1930–32 Age 13–15
Discovery Harlem

background:
Children playing leapfrog on the street, May 1932.

Identity

background:
Boys looking at metal art project.

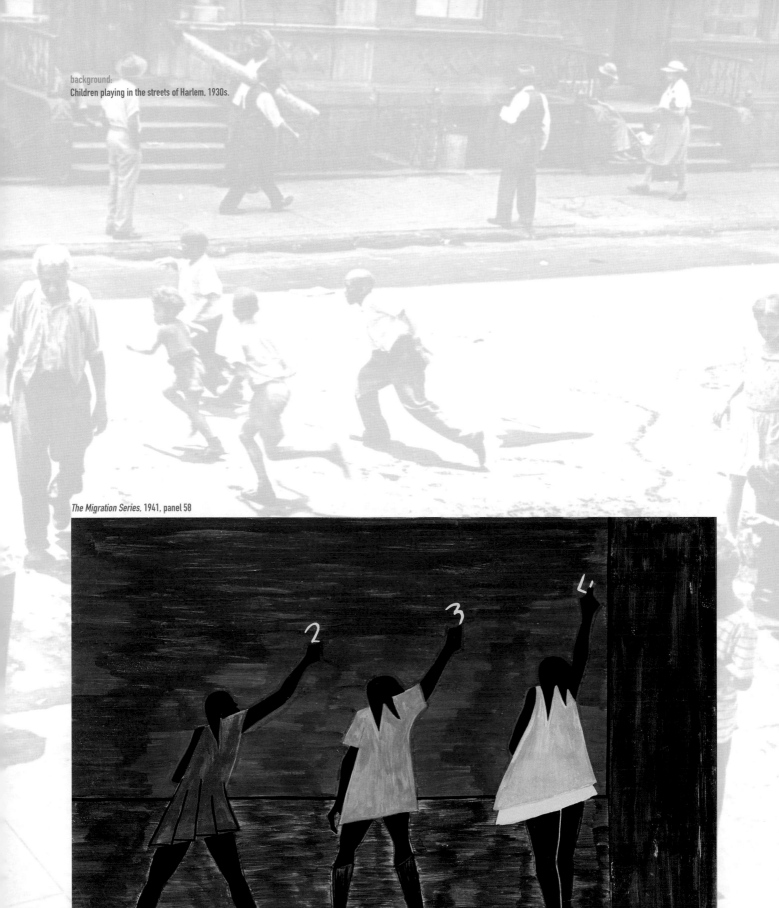

background:
Children playing in the streets of Harlem, 1930s.

The Migration Series, 1941, panel 58

Mesmerized

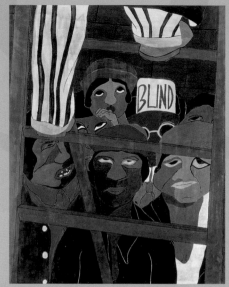

Street Orator's Audience, 1936

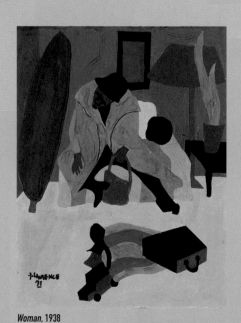

Woman, 1938

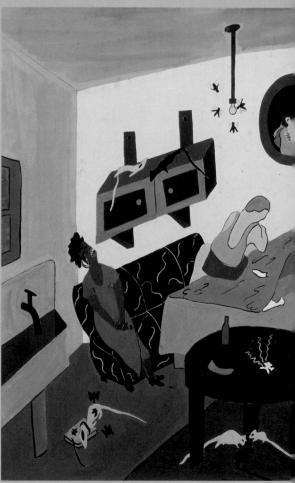

Interior Scene, 1937

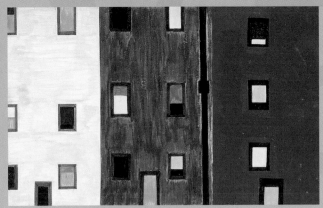
The Migration Series, 1941, panel 31

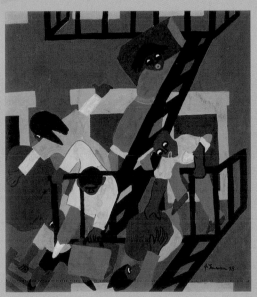
Fire Escape, 1938

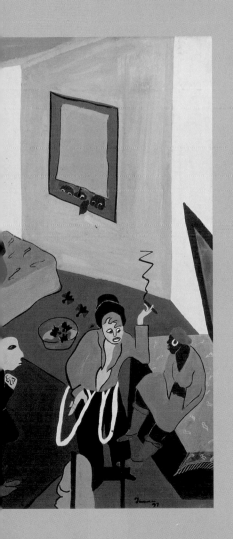

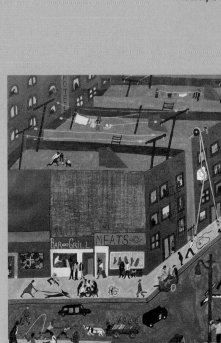
Harlem Street Scene, 1942

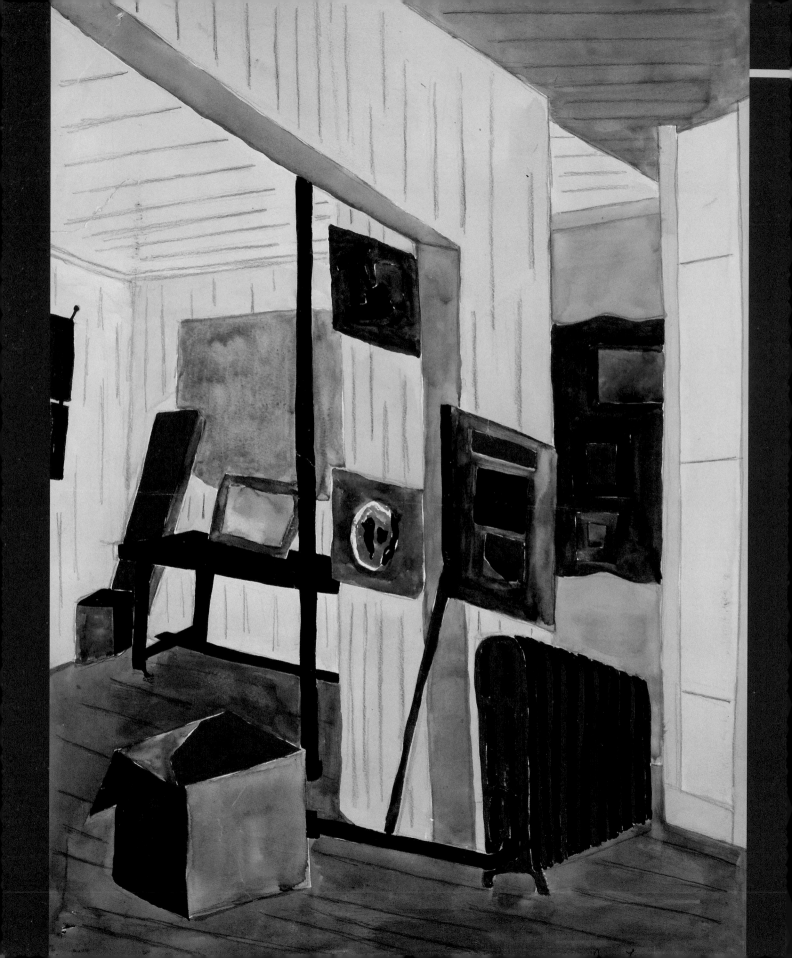

Workshop Table

In 1932, Charles Alston set up the Harlem Art Workshop in the basement of the 135th Street Schomberg Public Library, and Lawrence followed him there. The workshop became Lawrence's home away from home, and its librarians and teachers became his extended family. In the 135th Street library, there was a large collection of literature and artifacts on African and African-American culture. In a few years, Lawrence would comb through these materials in his quest to learn more about African-American history to use to paint his stories.

A photograph of the Harlem Art Workshop from around 1933 shows Lawrence standing with other young people clustered around a worktable. There are no easels. Pens, pencils, brushes, ink, paint jars, and paper are within reach of all. A teacher in the photograph demonstrates how to print a design on fabric. The group was like a band of budding musicians, each member learning from the others and at the same time developing his or her own technique and style.

At the workshop table, Lawrence learned how an artist works. He learned the building blocks that construct a work of art. The exercises he practiced taught him the possibilities of working with line, color, space, and shape. For example, he learned that by drawing a line he could divide space, create

shapes, and lead the eye. He found that by varying the width and density of lines, the lines took on character, direction, and energy. Lawrence discovered that lines and space create a visual language similar to the way sounds and space create music.

When he worked on an exercise about color, Lawrence saw that one color placed next to another changed the hues so that they seemed to either vibrate or quiet down. He found that color can create space and balance. He experimented with simple color shapes to produce things that people would recognize, and discovered he needed only a few colors to tell a story.

On regular field trips to the Metropolitan Museum of Art, Lawrence marveled at the way Renaissance painters made figures and objects in a picture look so real that he was tempted to reach out and touch them. He wondered how these artists had created such 3-D magic on a flat board or canvas using the basic elements of color, line, shape, and space. He noticed these paintings' stagelike settings and their simple drama. The workshop and the field trips taught him to appreciate all kinds of art and to use the same basic elements in his own art.

Hands-On

opposite:
Studio Corner, 1936

Developing a Style

At the workshop table, Lawrence spent time thinking about the rectangular space of the paper in front of him, called the picture plane. He considered how to fill it and how to divide it by putting down lines and shapes and adding color. His teachers encouraged him to depict the drama of his own life in his art; that is, to fill his picture with his experiences of the world around him—to paint what he saw. Working on his own, imagination free to roam, he would take a pencil and brown wrapping paper and draw a scene from his memory—perhaps two people sitting at a table, or a friend reading a letter, or a family saying grace before a meal. Once the lines and shapes were drawn and arranged, Lawrence would add his colors to finish the work.

The Harlem Art Workshop provided a place for Lawrence to develop his own style. Through exercises in ink and pencil, Lawrence acquired an awareness of the elements of art. He learned to fill his pictures with images and drama of his own choice; he created his own form of self-expression through his selection of line, color, and shape. This resulted in picture after picture of his family, his neighbors, his surroundings. Lawrence later said, "Being a youngster I could easily have been squelched by being told to do things this way or that way. The support I received from Alston's workshop was very important. As a result I had a self-assuredness about myself."

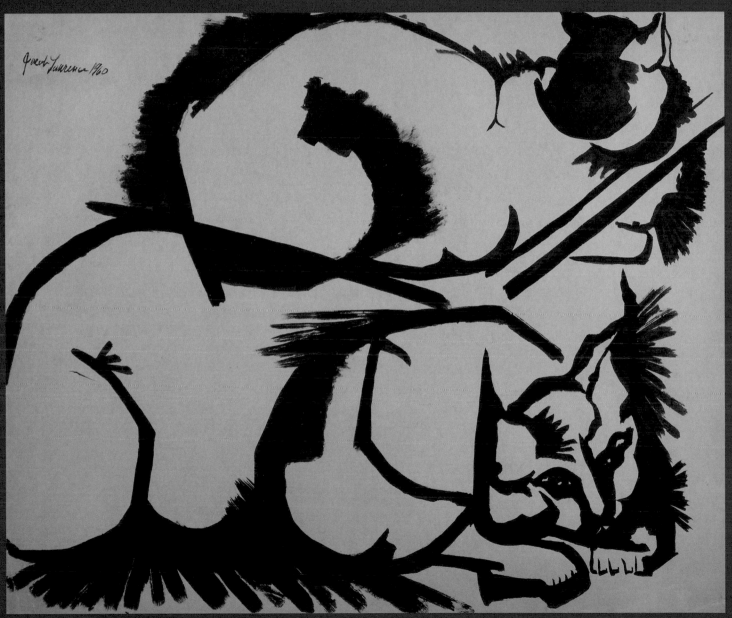

Two Cats, 1960

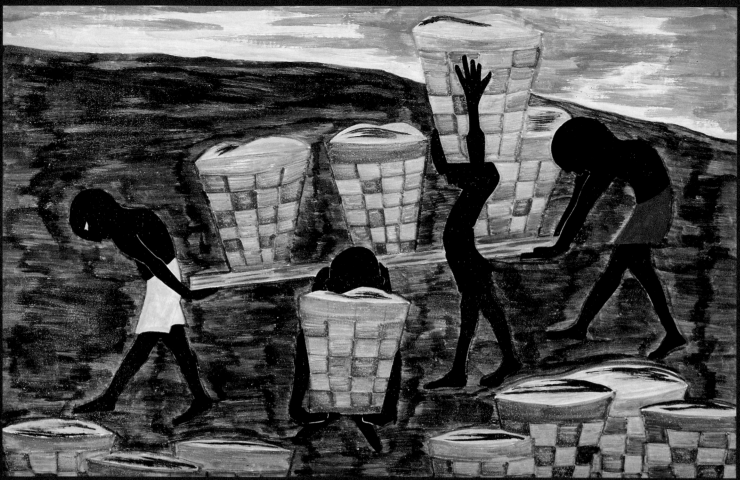

The Migration Series, 1941, panel 24

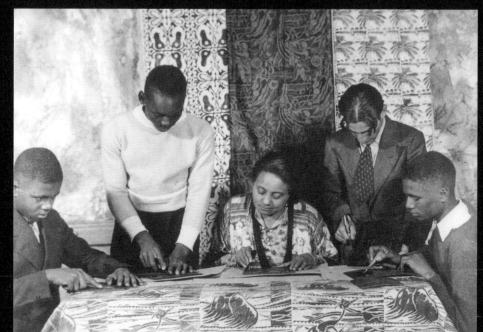

Jacob Lawrence (second from left) making block prints under the direction of Sarah West at the WPA Federal Art Project workshop, Harlem, ca. 1933–34.

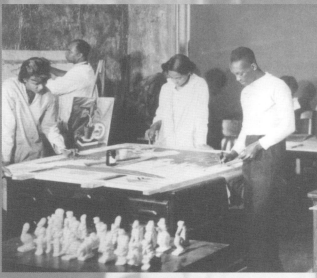
Jacob Lawrence (right) and other students with their teacher at
the WPA Federal Art Project workshop, Harlem, ca. 1933–34.

1932–34 Age 15–17
Hands-On Workshop Table
Developing a Style

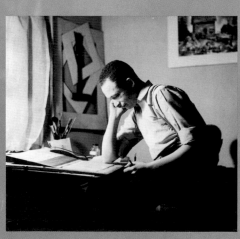
Charles "Spinky" Alston, early teacher
and mentor of Lawrence.

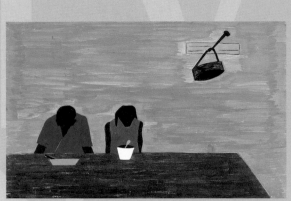

The Migration Series, 1941, panel 10

The Harriet Tubman Series, 1939–40, panel 25

Pool Players, 1938

Developing a Style

The Migration Series, 1941, panel 43

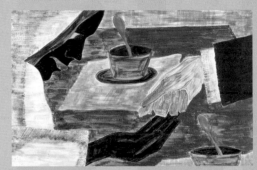

The Harriet Tubman Series, 1939—40, panel 24

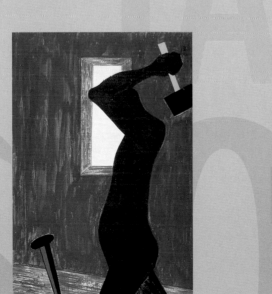

The Migration Series, 1941, panel 4

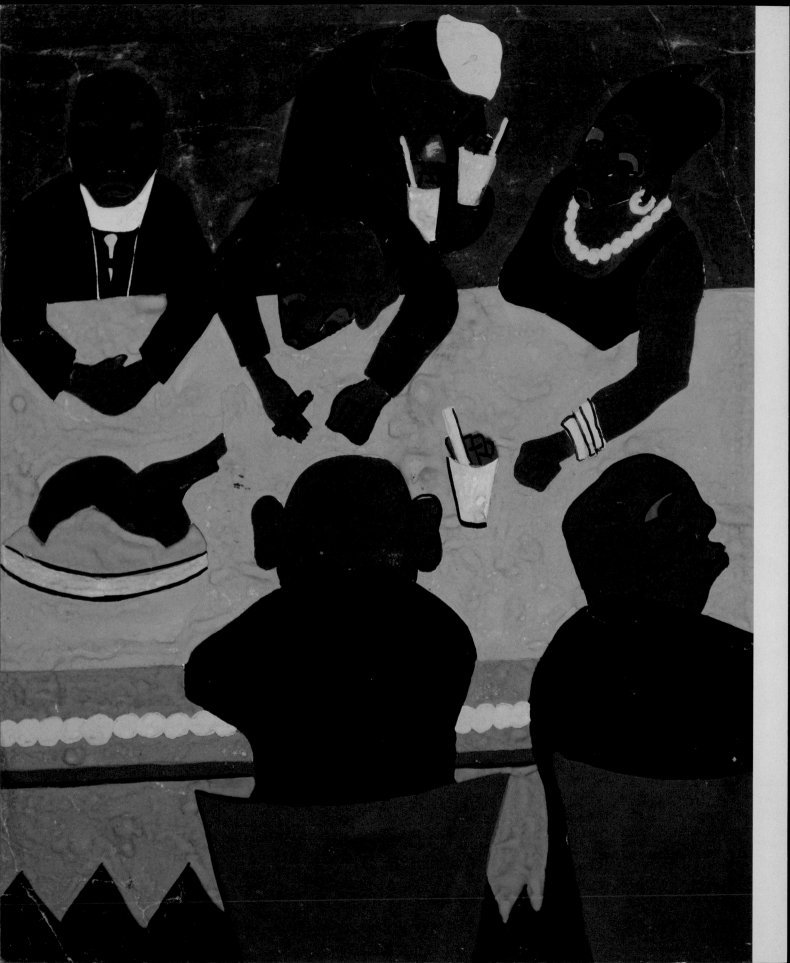

Studio 306

In 1934, as the Depression grew worse, Rosa Lawrence lost her job. Jacob Lawrence, now seventeen, left high school to help support the family. He delivered newspapers and liquor and worked in a print shop and a laundry. Although helping support his family was a factor in Lawrence's decision to leave school, his interest in art also played a part. In just four years, art had become Lawrence's passion. The workshops and the people he had met motivated him to achieve. Through research in the libraries and trips to museums, he continued to educate himself about art and history.

Around Town

In his spare time, Lawrence continued his art education with Charles Alston at the workshop, which was now called Studio 306 because of its new location at 306 West 141st Street in Harlem. The 306 workshop received money from the Works Progress Administration (WPA), one of the New Deal government programs set up by President Franklin D. Roosevelt's administration to help provide jobs during the Depression. The WPA funded many public projects that employed artists and writers. In addition to running Studio 306, Alston also supervised Harlem Hospital's mural project, another government program that employed artists.

Part training ground, part meeting and exhibition space, Studio 306 was buzzing with the creative energy of Harlem's artists. Lawrence later recalled meeting well-known African-American painters such as Aaron Douglas. Writers Langston Hughes and Claude McKay became Lawrence's friends. In a small corner of the center, he worked on his projects and listened to his elders, including actor Lee Whipper and musician Frank Fields. Alston hired Henry Bannarn, a sculptor, to teach at the 306 workshop. Whatever these more established artists were working on— poetry, music, painting, or a new play—they used the same words to describe their experiences, words like *space, color, texture, rhythm, gesture,* and *line.* They described the challenges they faced in capturing an emotion or a gesture by filling a space or leaving it empty, or making something with a flourish. Lawrence realized he faced the same challenges in his own work. "These art forms are . . . interwoven," he later said. As he watched, listened, and learned about current trends from these more experienced artists, Lawrence came to share their desire to tell the African-American story in a new way.

Among his peers at 306, Lawrence met his future wife, Gwendolyn Knight, who was one of Alston's mural painters for Harlem Hospital. Born in the West Indies, Knight had also migrated north to Harlem as a teenager. She was a beautiful young woman and had studied art at Howard University in Washington, D.C., until the Depression. In Harlem, she joined artist Augusta Savage's studio, another WPA center like Studio 306.

opposite:
Dining Out, 1937

Witness

Lawrence, Knight, and other friends took full advantage of New York City's museums, movie houses, galleries, theaters, and music clubs. They covered the entire city of Manhattan. They found that downtown gallery doors opened reluctantly to African Americans, but undaunted by the white art world's cool reception to blacks, they proceeded to explore the city's culture. They viewed themselves as part of the contemporary art scene.

Later in life, Lawrence and Knight recalled a particular exhibition, *African Negro Art*, organized by the Museum of Modern Art (MOMA) in 1935. "I had never seen anything like that," Knight said. "It was really interesting to see what the African . . . carvers had done. It was so full of energy." For both Lawrence and Knight, the exhibition left them with a new appreciation for the artists Matisse and Picasso, whose art had been inspired by the lines and forms of African art. Historian Charles Seifert, who accompanied Lawrence and Knight to the exhibition, encouraged Lawrence to study the roots of African-American history and culture.

In 1936, at the Lafayette Theater, Lawrence saw a play about Toussaint L'Ouverture (1743--1803). The courageous Haitian slave freed not only himself but all of Haiti's slaves, and then governed the island. Lawrence saw how telling the story of a black hero, just like the Bible stories he had heard in church, had power. The story's nightly repetition on stage had the potential to reach and inspire many people. Lawrence became curious about Toussaint and other black heroes. He wanted to learn more. He would go to the 135th Street library to research, reading books and looking at old illustrations. Perhaps in time, he too would be a storyteller, but with pictures.

During this period, Lawrence also went to plays at Harlem's Apollo Theater and noticed how actors and comedians drew from the material of

Woman with Veil, 1938

real life. He and his friends were amazed at how the distressing details of the Depression—such as hunger, rats, and greed—could make an audience laugh. "I would leave the Apollo Theater and go out on the street, and it was like a continuation of what was happening on the stage," Lawrence said.

Back in his corner studio at 306, Lawrence worked on recording what he saw in Harlem—the landlord evicting a family, the junkman pushing his cart, the fancy woman with the net drawn over her face. These images were simple but clear. He was creating his own kind of theater about everyday life. His characters' gestures conveyed the humor he saw in a burst of anger, the grace he observed in an act of labor, and the silliness he saw in the behavior of a show-off. On the stage of his small picture plane, Lawrence's choices of subject and style showed not only what he saw, but how he saw it, the reality and what was behind it, the people, and what he thought about them. Lawrence was becoming a young reporter with paint, a critic with a careful eye on Harlem. When his work was exhibited at 306, fellow artists saw and appreciated the honesty of his subject matter and the directness of his technique. The Harlem community was buying his art.

Lawrence used every possible experience as an opportunity to make art. In 1936, he went to Middleton, New York, to dig ditches at a dam site for the Civilian Conservation Corps, another New Deal program. While there, he made six drawings as a record of his experience. He noted the expressions and gestures of his fellow workers as they grabbed for food at the dinner table, had a doctor's examination, or rubbed a friend's aching back at the end of a hard workday. Each drawing is a pleasing picture of fluid lines interwoven with surrounding space.

In 1937, the drawings were exhibited at the 115th Street public library. Lawrence was praised for his increasing skill. His unique method of capturing a scene from memory showed his ability to make art out of the everyday experiences of life.

Also in 1937, Lawrence received a scholarship to attend classes at the American Artists School, located in downtown Manhattan on 14th Street. Some of the more political art students there called themselves communists. Their ideas may have reinforced Lawrence's growing awareness that he could entertain, teach a lesson, express an idea, and comment about his world in his art. Through exhibitions at the school, Lawrence's work was introduced to new audiences, who again and again declared his talent.

What to paint, whether or not to paint, and how to paint were never burning questions for Lawrence. However, how to make his art into a career did concern him. Perhaps of all the people he met during his years at 306, sculptor Augusta Savage was the most important. Savage gave Lawrence a kind of support and encouragement his own mother had been unable to provide him. She would help Lawrence make art into a career.

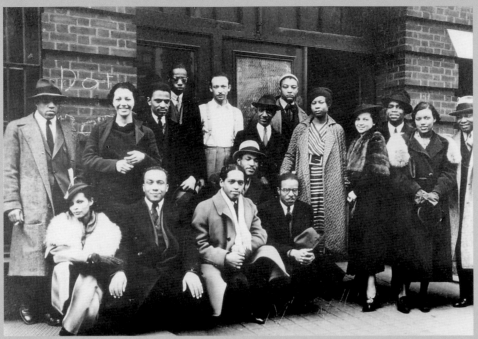

"306" group in front of 306 West 141st Street. Gwendolyn Knight, Lawrence's future wife, below left.

1934–37 Age 17–20
Witness Studio 306
Around Town

Augusta Savage. Lawrence visited Savage's open studio, and she later recommended him for a job with the WPA.

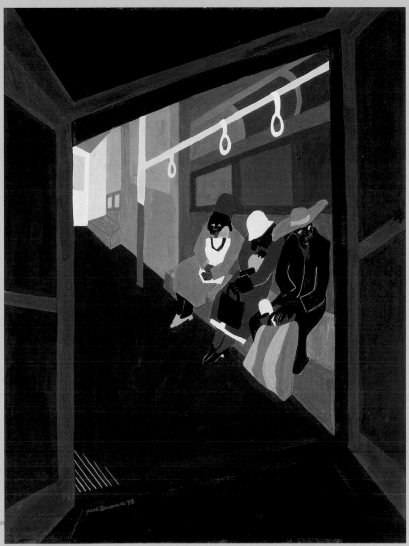

Subway, 1938

Charles Alston. *Magic and Medicine*,
1937, Harlem Hospital.
Lawrence watched Alston paint a
mural commissioned by the WPA.

Jake's Home
143 W. 142d

306 W. 141st

W. 135th

Schomburg Center

Utopia House
170 W. 130th

W. 125th

Apollo Theater

Fifth Avenue

Metropolitan
Museum of Art

Art Galleries
East 57th

W. 53rd

Museum of
Modern Art

W. 42nd

W. 14th

American Artists
School

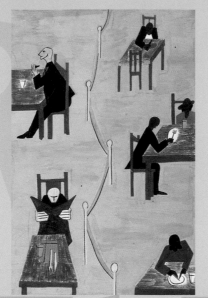

The Migration Series, 1941, panel 49

AROUND

Studio 30

Learn

Apart

STUDE

Witness

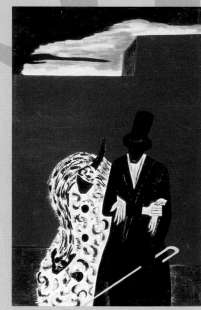

The Migration Series, panel 53

Belief

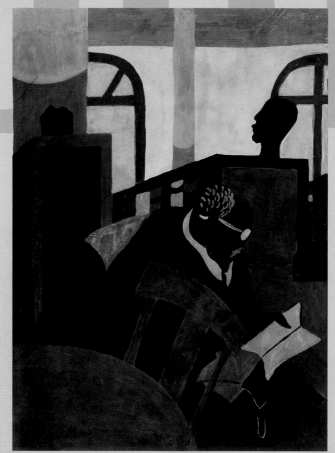

Library, 1937

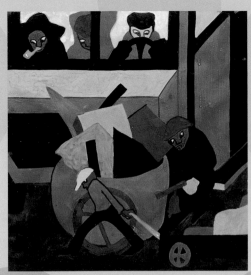

Junk, 1937

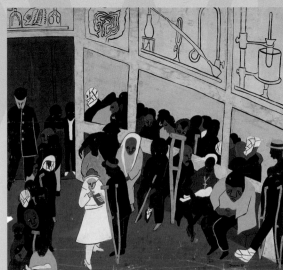

Free Clinic, 1937

Labor

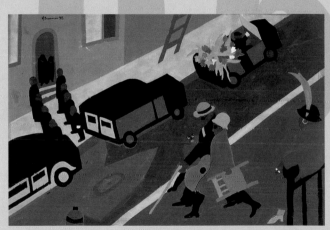

Dust to Dust, 1938

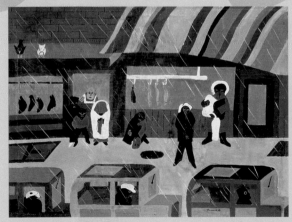

The Butcher Shop, 1938

Regard

Around Town

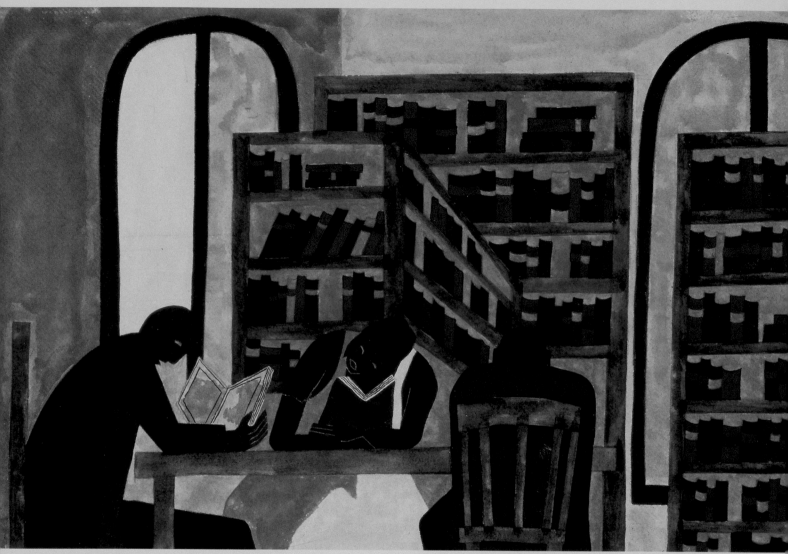

The Libraries Are Appreciated, 1943

Getting

Artist with a Capital "A"

On September 7, 1938, Jacob Lawrence turned twenty-one. He never forgot how Augusta Savage remembered his birthday and hurried him off to sign up as a WPA artist. From that moment on, with a steady paycheck, Lawrence thought of himself as an artist with a capital "A." At last he could focus on art full time.

"I had no idea up until the time that I was hired by the Federal Art Project [under the WPA] . . . that my works would be purchased. I knew that I would always be painting, and thought that I would always have to support myself by doing other things, like working in a laundry," Lawrence said. As a member of the WPA's easel project, Lawrence's assignment was to produce two paintings every six weeks. He was paid about $30 a week, or "as much as for a man's suit," he later said. He continued to use water-based poster paints and lightweight brown wrapping paper and to record scenes of Harlem's daily life. He worked hard, developing his artistic language to tell stories.

Older WPA artists were invited to paint murals. Murals were large paintings on walls, painted in public spaces and intended to teach the viewer about a certain time or a certain profession or to celebrate nature or the arts. Lawrence was too young to be considered for a commission to paint a mural, but he was impressed with how a mural could inspire, like a sermon or music. He had watched Alston work on his Harlem Hospital mural. He had seen Aaron Douglas's mural *Aspects of Negro Life* (1934) at the 135th Street library. He saw how artists working on murals collapsed historical time and melded scenes.

Lawrence was "too young for a wall," but he could tackle showing long periods of time and large numbers of events if he stayed in his own format—small paintings. All he had to do was paint a number of small paintings—depicting individual scenes—and hang them together in a row. Lawrence was "too young for a mural," but he wasn't too young—and he certainly had enough ideas and enough energy—to fill up a wall.

The series format that Lawrence invented for telling significant stories about the African American experience—stories about Toussaint L'Ouverture and others—had the advantage of being portable and inexpensive to produce. The series was easy to read—like comic strips—and worked together as a whole—like film strips. In fact, it may have been comics and film strips that inspired Lawrence's invention, according to his wife, Gwendolyn. Like comics, Lawrence explained each panel in his series with a caption that was short, poetic, and based on hours of research at the library.

Respect

Downtown

For his first series about Toussaint L'Ouverture, Lawrence created over forty informative captions and compositions. The individual scenes were made up of simplified forms, limited but vivid colors, and theatrical gestures—techniques that were already part of his style. He kept the actors and the action close to the front of the picture plane so that the meaning of each piece was both clear and compelling. Each panel used repetition of pattern, line, and shape. The result was a harmonious composition with a dynamic rhythm.

Lawrence's story of Toussaint L'Ouverture, like the play *Haiti* that inspired it, was shown many times in many places, but it was the first of his artworks to be seen in a museum and to reach beyond Harlem's audiences. The Baltimore Museum of Art was the first to exhibit *The Life of Toussaint L'Ouverture*, in 1939.

A period of intense painting followed. Between 1938, when Lawrence completed the Toussaint series, and 1940, Lawrence celebrated two more African-American historical heroes in series: *The Life of Frederick Douglass* (1939; thirty-two wood panels) and *The Life of Harriet Tubman* (1940; thirty-one wood panels).

During this period, Lawrence continued to learn from what he saw around him. In 1939, he watched the famous Mexican muralist José Clemente Orozco working on his *Dive Bomber and Tank* mural at the Museum of Modern Art. The younger artist asked Orozco about his sketches for the mural and was amazed to hear that Orozco didn't make elaborate sketches; he worked directly on the wall after making a few initial "chicken-scratch" marks on pieces of cardboard, the kind that came with laundered shirts. Lawrence later recalled with some amusement that trying to be helpful, he had asked Orozco if he could get him anything. The older artist had answered, "Yes, I would like some cherries." Lawrence smiled when he later explained how he had bought some cherries from a street vendor, glad to be of some small use to an artist whose work he admired.

Lawrence was becoming known in his own way as he began to show his work more often. Reviews were favorable from both black and white critics. *Newsweek* declared him a "discovery," and *ARTnews* called his draftsmanship "accomplished." Alain Locke, in *Opportunity* magazine, pronounced him a "genius," whose style had a "universal appeal" not limited to the world his art depicted. ■

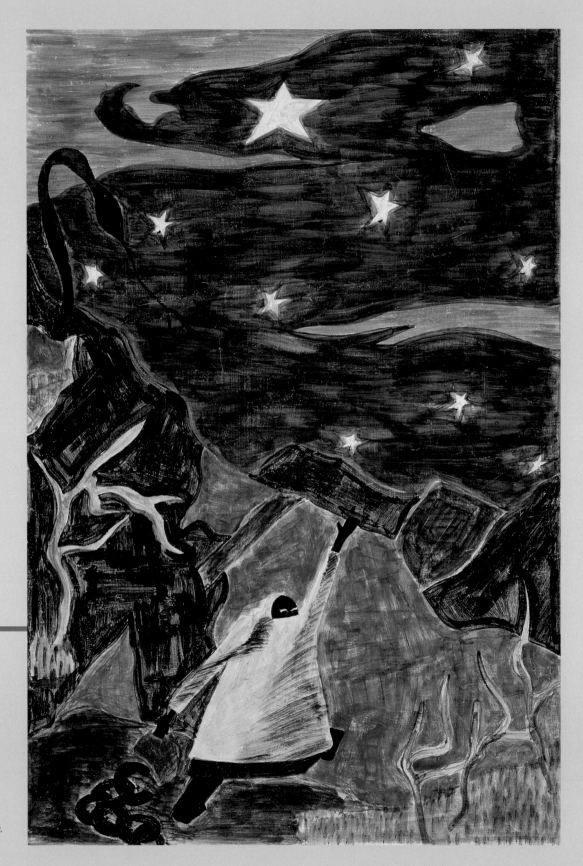

The Harriet Tubman Series,
1939–40, panel 10

The praise from wider circles was satisfying, but Lawrence was a man with a mission. He pursued his creativity with the conviction that the work is its own reward. He never sought praise but continued to receive it, in addition to prizes, from places as distant as Chicago. He applied for and won fellowships—worth up to $1,500—to continue his work. As his reputation grew, he used his paintings to secure loans from supporters.

In 1940, Lawrence applied for and received a fellowship from the Julius Rosenwald Fund. This enabled him to rent his own studio at 33 West 125th Street at a cost of $8 a month. Now he could start his largest and most ambitious story. It would draw on his full range of talents and be based on oral-history tradition and research. It would tell the story of his family, the people he listened to in Philadelphia, and his Harlem neighbors. It would be the story of all the unsung heroes who migrated to the North from the South during and after World War I.

In the larger space of his new studio, Lawrence worked with Gwendolyn Knight to prepare the story. As he envisioned it, the series would require sixty panels with captions and hours of research and writing. It would take meticulous planning for the designs and careful selection and plotting of colors. Again, Lawrence used small, hardboard panels, some vertical and some horizontal. He and Gwendolyn sanded and resanded all sixty panels and applied and reapplied gesso. Together they built makeshift tables out of wood planks supported by sawhorses. Lawrence transferred his sketches to the panels and applied the paints, undiluted, flat, and one color at a time for consistency. It was arduous work, but Lawrence recalled the pleasure it gave him to be so engaged. He said that when he and Gwendolyn got hungry, working late in the cold-water studio, they used a hot plate, or "two burner," to heat a simple can of beans.

As he worked, Lawrence worried more about structure than detail. Of utmost importance to him was the arrangement of parts and the direction and nature of lines. His forms became intensely expressive. "I always wanted the idea to strike right away," he later explained. Thus his figures were not only individuals he saw on the street, they were also symbols. The women bent over, recoiling, or reaching for the stars represented grief, anger,

or hope. Clouds, water, trees, and flocks of birds represented danger, hope, shelter, and freedom. He later described his work as "a self-portrait, a still life, a landscape."

When he finished *The Migration Series* in 1941, Edith Halpert, a prominent art dealer in New York, made it the focal point of a show at her Downtown Gallery the same year. With *The Migration Series* hanging in one of New York's foremost galleries—a gallery that up until then had shown work by white artists only—Lawrence had crossed a significant barrier. Within the art world that existed outside the boundaries of Harlem, Lawrence's career, and that of other African Americans to follow, had been launched. Ironically, Lawrence missed the opening of that show. He and Gwendolyn, newly married, were already on another quest, this time to New Orleans, where he would paint another series, the story of John Brown.

From foster child to esteemed and self-supporting artist in New York, Lawrence's journey to manhood was full of difficult hurdles, but also, as he always pointed out, opportunity and support. At age twenty-five, he was already a respected artist, exhibiting in numerous venues and regularly at Halpert's Downtown Gallery. Perhaps it was a natural step for Lawrence to decide to teach. He became a visiting teacher in the New York City public schools and also taught at summer camps and workshops. Eventually he taught college art. Following the example of his teacher Charles Alston, Lawrence mentored the next generation of aspiring artists. He gave back.

As an artist and then as a teacher, he used his mature awareness, his keen observation, his memory, and his imagination to tell stories that everyone could understand. His message was always there:

He struggles,
she struggles,
we all struggle.
There is beauty in each of our
individual and shared struggles.
When we see him, we see ourselves.

The Migration Series on view at the Downtown Gallery, 1941.

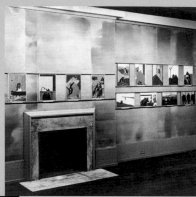

Museum Exhibition

Gallery Exhibition

Jacob Lawrence presenting a panel from his *Life of Toussaint L'Ouverture* series to the registrar at the Baltimore Museum of Art, 1939.

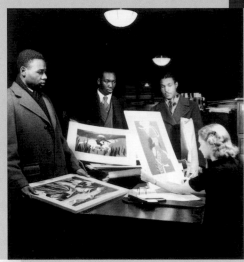

Painting

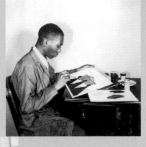

Jacob Lawrence, ca. 1941

Research

Reading room at the 135th Street library, ca. 1930, where Lawrence spent many hours doing research for his history series paintings.

1942 age 25
lectures at public schools in New York

1941 age 24
exhibits *The Migration Series* at the Downtown
Gallery; marries Gwendolyn Knight

Fame

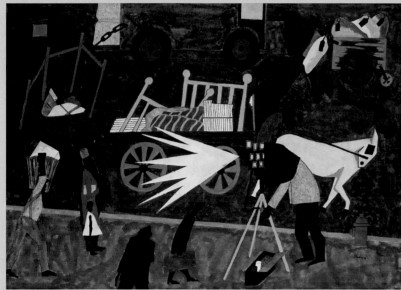

The Photographer, 1942

Giving Back—Teaching

Jacob Lawrence lecturing on his
art at Lincoln School, New Rochelle,
New York, on February 28, 1941.

1940 age 23
wins Julius Rosenwald
Fellowship

1939 age 22
exhibits *The Life of Toussaint
L'Ouverture* series at the
Baltimore Museum of Art

1938–41 Age 21–25

Downtown Artist with a
Getting Capital
Respect "A"

1938 age 21
hired by WPA

Top row, left to right: *The Harriet Tubman Series*, 1939—40, panels 1, 18, 23, 9, and 26

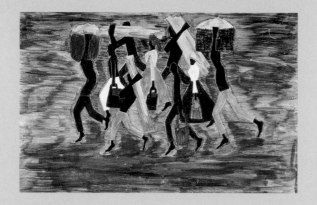

" *There is*

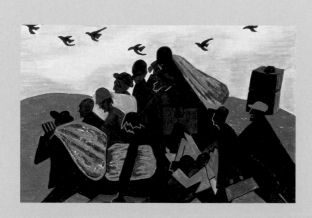

Bottom row, left to right: *The Migration Series*, 1941, panels 3, 9, 52, 22, and 51

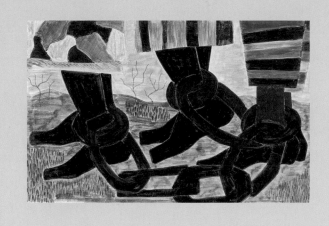

beauty

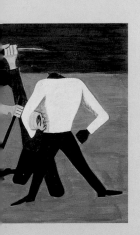

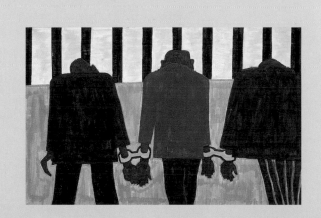

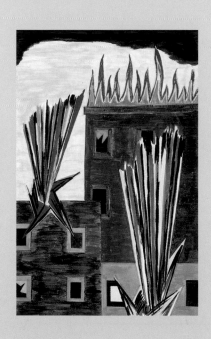

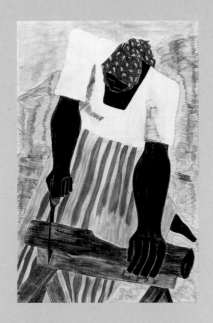

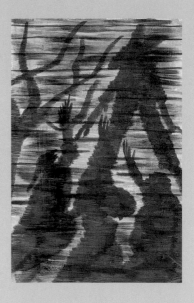

. . . . *in the*

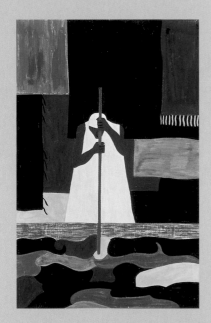

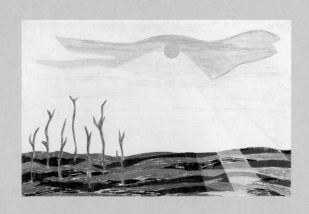

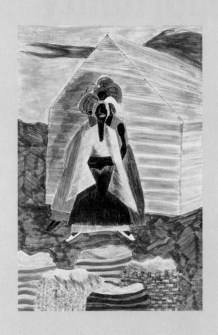

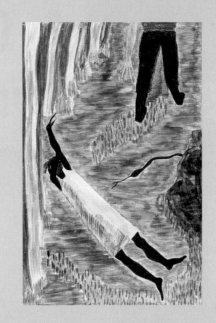

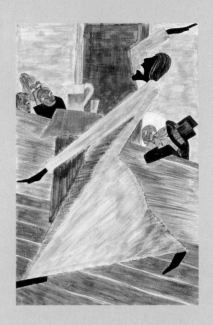

"struggle."

— Jacob Lawrence

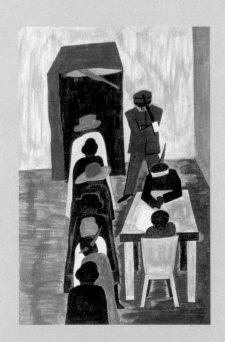

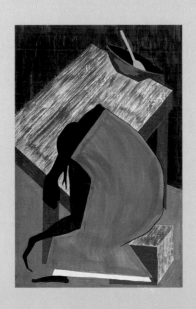

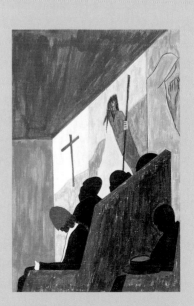

Glossary

brownstones—houses built of brown or red sandstone

color—the name of a hue and an element of art

gesture—a specific pose, stance, or motion of a person or artist's model

composition—the arrangement of the elements of art, usually according to the principles of design

density—the quality of being dense (marked by compactness or crowding together of parts)

evoke—to call forth or to re-create imaginatively

flat—having only one or two dimensions

form—a shape made three dimensional by shading, color, or line, such as a cube or a sphere; an element of art

line—a continuous mark that moves from one point to another; an element of art

migration—the movement of large numbers of people or animals from one place to another

mural—a painting applied directly to a wall or ceiling

pattern—a two-dimensional unit that repeats within a design or composition

picture plane—the surface area of a painting or drawing

poster paint—tempera paint, a water-based paint

renaissance—means "rebirth." The term is used to describe a new and energized interest in art and ideas expressed in different ways, such as painting, poetry, and music. Examples include the Italian Renaissance of the fourteenth and fifteenth centuries and the Harlem Renaissnce of the 1920s.

repertoire—a complete list of skills or capabilities

repetition—a unit or element that repeats in a composition and may create movement or emphasis in a work of art; a principle of design

rhythm—visual movement that occurs from one element to another; a principle of design

shape—an element of art created when a line or lines completely surround a thing such as a circle or square

space—the area that surrounds a shape, form, or line; an element of art

structure—the manner in which a composition is arranged or organized

symbol—a sign, form, or image that represents another meaning

universal—that which is similarly understood by everyone

Chronology

**Jacob Lawrence
as a Young Artist
Birth to Age 25**

1917 Born in Atlantic City, New Jersey, to Jacob and Rosa Lee Lawrence.

1919 *Age 2* Family moves to Easton, Pennsylvania.

1924 *Age 7* Parents separate and mother moves Jacob and his younger sister and brother to Philadelphia, Pennsylvania.

1927 *Age 10* Mother leaves to find work in New York City and places the three children in foster homes in Philadelphia.

1930 *Age 13* Mother reclaims children and moves them to Harlem in New York City.

1932 *Age 15* Lawrence decides to drop out of high school and study under Charles Alston at the Harlem Art Workshop at the 135th Street Public Library. He works part time to help support the family.

1934–36 *Age 17–19* Continues his studies with Alston who is now associated with the Works Progress Administration's (WPA) Harlem Workshop at 306 West 141st Street. Rents corner space in Alston's studio. Works for Civilian Conservation Corps.

1937 *Age 20* Offered scholarship to study under leading American artists at the American Artists School at 131 West 14th Street.

1938 *Age 21* Hired by the WPA Federal Art Project. Earns $23.86 per week. Completes *The Life of Toussaint L'Ouverture* series, the first of his historical narrative paintings. Exhibits at the Harlem YMCA and the Baltimore Museum of Art.

1939–40 *Age 22–23* Paints *The Life of Frederick Douglass*, *The Life of Harriet Tubman*, and *The Migration Series*. Wins Julius Rosenwald fellowship and rents his own studio space.

1941 *Age 24* Marries Gwendolyn Knight. Paints *The Life of John Brown* series. First major one-man exhibition, *The Migration Series*, at Edith Halpert's Downtown Gallery. Joins the Downtown Gallery.

1942 *Age 25* Visits mother's family in Lenexa, Virginia. Awarded Sixth Purchase Prize, *Artists for Victory* exhibition, the Metropolitan Museum of Art. Works as summer art instructor at Workers Children's Camp in Hackettstown, New Jersey.

From 1942 on, Jacob Lawrence continued to paint works based on his life, work, and travels. In 1943, he was inducted into the United States Coast Guard, where he served for a year. In 1946, Lawrence taught with Josef Albers at Black Mountain College in Asheville, North Carolina. In 1950, he spent a year undergoing psychiatric treatment at Hillside Hospital in Queens, New York. In 1955, he painted thirty panels of a series titled *Struggle . . . From the History of the American People*, and in 1982, the Hiroshima paintings. In 1962, the Lawrences visited Africa. Lawrence taught at the New School for Social Research, New York City, from 1966 to 1969. In 1970, he accepted a job as full professor at the University of Washington in Seattle, where he and his wife lived until his death in 2000. Throughout his career, Lawrence continued to show his work, to lecture, and to receive acclaim. In 1969, he became a member of the Black Academy of Arts and Letters, and in 1984, he was inducted into the American Academy of Arts and Letters.

Acknowledgments

A special thanks goes to the staff of
The Phillips Collection for allowing this book
to come to life and for granting the author the free-
dom to create on her own: to Thora Colot, who con-
ceived of the project; to senior curator Elizabeth
Hutton Turner, who guided its thematic direction;
and to Suzanne Wright, Karen Schneider, Elsa
Mezvinsky Smithgall, and Johanna Halford-MacLeod
for their feedback and administrative support.

The author also wishes to thank Joyce Bucci,
Supervisor of Art, Baltimore County Public Schools,
Maryland; Barbara Halpern; Judy and Joel Havemann;
Debra Marks; St. Ambrose University Library, Daven-
port, Iowa; Ernestine Schlant; Sara Schneckloth;
Jackson Frost; and the Jim Leach family, for their
support and patience, in particular Jenny, for her
help with words. To Osa Brown, Donna Denizé, and
to many others, thank you for reading the manu-
script closely and offering comments.

Thank you, Laura Wesley Ford, for helping to
prepare the glossary, and Gail Spilsbury for your
thoughtful editing.

Toni Morrison's permission to use her words as
an introduction cannot be acknowledged adequately
with mere thanks.

And finally, the importance of Gwendolyn Knight
Lawrence's blessing to proceed with this project
cannot be measured in words.

Note to the Reader

I See You, I See Myself: The Young Life
of Jacob Lawrence is based on stories told to
The Phillips Collection staff and the author in 1992
and 2000, in preparation for two Jacob Lawrence
exhibitions, Jacob Lawrence: The Migra-
tion Series (1993) and Over the Line:
The Art and Life of Jacob Lawrence
(2001). All of the Jacob and Gwendolyn Knight
Lawrence quotations in the book are from those
interviews.

The illustrations and accompanying captions of
works by Jacob Lawrence that appear in this book
are cited in the list of illustrations. The list also
includes the owners of artworks and photographs
reproduced in the book.

List of Illustrations

Photograph. Children playing in the streets of Harlem. 1930s. National Archives.

Interior Scene. 1937. Tempera on illustration board. 28½ × 33¾ in. Collection of Phillip J. and Suzanne Schiller. American Social Commentary Art. 1930–1970.

Woman. 1938. Tempera on paper. 11¾ × 9 in. Collection of Mrs. Suzanne Schwartz Cook.

Street Orator's Audience. 1936. Tempera on paper. 24⅛ × 19⅛ in. Tacoma Art Museum. gift of Mr. and Mrs. Roger W. Peck by exchange.

"After arriving North the Negroes had better housing conditions." *The Migration of the Negro*. 1941. panel 31. Casein tempera on hardboard. 12 × 18 in. The Phillips Collection. Washington. D.C.. acquired 1942.

Fire Escape. 1938. Tempera on paper. 12¼ × 10⅞ in. Collection of Jules and Connie Kay.

Harlem Street Scene. 1942. Gouache on paper. 21 × 20¾ in. Collection of Dr. Kenneth Clark.

Workshop Table

Studio Corner. 1936. Watercolor on paper. 24¼ × 18¼ in. Private collection.

Two Cats. 1960. Brush and ink on brown paper. 20 × 24 in. Collection of Gwendolyn Knight Lawrence. Courtesy of DC Moore Gallery. New York.

"Child labor and a lack of education was one of the other reasons for people wishing to leave their homes." *The Migration of the Negro*. 1941. panel 24. Casein tempera on hardboard. 12 × 18 in. The Museum of Modern Art. New York. Gift of Mrs. David M. Levy. 1942.

Photograph. Jacob Lawrence (second from left) making block prints under the direction of Sarah West at the WPA Federal Art Project workshop. Harlem. ca. 1933–34. National Archives. Harmon Foundation Collection.

Photograph. Jacob Lawrence (right) and other students with their teacher at the WPA Federal Art Project workshop. Harlem. ca. 1933–34. National Archives. Harmon Foundation Collection.

Photograph. Charles "Spinky" Alston. early teacher and mentor of Jacob Lawrence. National Archives. Harmon Foundation Collection.

Pool Players. 1938. Tempera on brown paper. 17¾ × 11¾ in. Collection of AXA Financial through its subsidiary The Equitable Life Assurance Society of the U.S.

The Life of Harriet Tubman. 1939–40. panel 25. Casein tempera on hardboard. 17⅞ × 12 in. Gift of the Harmon Foundation. Hampton University Museum. Hampton. Virginia.

"They were very poor." *The Migration of the Negro*. 1941. panel 10. Casein tempera on hardboard. 12 × 18 in. The Museum of Modern Art. New York. Gift of Mrs. David M. Levy. 1942.

"In a few sections of the South the leaders of both groups met and attempted to make conditions better for the Negro so that he would remain in the South." *The Migration of the Negro*. 1941. panel 43. Casein tempera on hardboard. 18 × 12 in. The Phillips Collection. Washington. D.C.. acquired 1942.

"It was the year 1859. five years after Harriet Tubman's first trip to Boston. By this time. there was hardly an antislavery worker who did not know the name Harriet Tubman. She had spoken in a dozen cities. People from here and abroad filled her hand with money. And over and over again. she made her mysterious raids across the border into the South." *The Life of Harriet Tubman*. 1939–40. panel 24. Casein tempera on hardboard. 17⅞ × 12 in. Gift of the Harmon Foundation. Hampton University Museum. Hampton. Virginia.

"The Negro was the largest source of labor to be found after all others had been exhausted." *The Migration of the Negro*. 1941. panel 4. Casein tempera on hardboard. 18 × 12 in. The Museum of Modern Art. Gift of Mrs. David M. Levy. 1942.

Studio 306

Dining Out. 1937. Gouache on paper. 11½ × 9 in. Collection of the Madison Art Center. Madison. Wisconsin. Gift of the Estate of Janet Ela.

Woman with Veil. 1937. Tempera on brown paper. 17 × 13½ in. The Walter O. Evans Collection of African American Art.

Photograph. "306" group in front of 306 West 141st Street. Gwendolyn Knight. Jacob Lawrence's future wife. below left. National Archives. Harmon Foundation Collection.

Photograph. Augusta Savage. Jacob Lawrence visited Savage's open studio. and she later recommended him for a job with the WPA. National Archives. Harmon Foundation Collection.

Subway. 1938. Tempera on illustration board. 20 × 15½ in. Schomburg Center for Research in Black Culture. Art and Artifacts Division. The New York Public Library. Astor. Lenox and Tilden Foundations.

Photograph. Charles Alston. *Magic and Medicine*. 1937. Harlem Hospital. Jacob Lawrence watched Alston paint a mural commissioned by the WPA.

Map. Area of Manhattan that Lawrence frequented in the mid-1930s. Map by Melanie Milkie.

"They also found discrimination in the North although it was much different from that which they had known in the South." *The Migration of the Negro*. 1941. panel 49. Casein tempera on hardboard. 18 × 12 in. The Phillips Collection. Washington. D.C.. acquired 1942.

"The Negroes who had been North for quite some time met their fellowmen with disgust and aloofness." *The Migration of the Negro*, 1941, panel 53. Casein tempera on hardboard, 18 × 12 in. The Phillips Collection, Washington, D.C., acquired 1942.

Library, 1937. Tempera on paper, sight: 11½ × 8½ in. Schomburg Center for Research in Black Culture, Art and Artifacts Division, The New York Public Library, Astor, Lenox and Tilden Foundations.

Junk, 1937. Tempera on paper, 17⅞ × 12 in. Collection of John P. Axelrod, Boston.

Free Clinic, 1937. Tempera on paper, 28 × 29½ in. The Art Institute of Chicago.

The Butcher Shop, 1938. Tempera on paper, 17½ × 24 in. Private collection, New York.

Dust to Dust, 1938. Tempera on paper, 12½ × 18¼ in. Collection of Gwendolyn Knight Lawrence. Courtesy of Francine Seders Gallery, Seattle.

Artist with a Capital "A"

The Libraries Are Appreciated, 1943. Gouache on paper, 14¹¹⁄₁₆ × 21⅝ in. Philadelphia Museum of Art: The Louis E. Stern Collection, 1963.

"Harriet Tubman was between twenty and twenty-five years of age at the time of her escape. She was now alone. She turned her face toward the North, and fixing her eyes on the guiding star, she started on her long, lonely journey." *The Life of Harriet Tubman*, 1939–40, panel 10. Casein tempera on hardboard, 17⅞ × 12 in. Gift of the Harmon Foundation, Hampton University Museum, Hampton, Virginia.

Photograph. *The Migration of the Negro* series on view at the Downtown Gallery, 1941. National Archives, Harmon Foundation Collection.

Photograph. Jacob Lawrence presenting a panel from his *Life of Toussaint L'Ouverture* series to the registrar at the Baltimore Museum of Art, 1939. National Archives, Harmon Foundation Collection.

Photograph. Jacob Lawrence, ca. 1941. National Archives, Harmon Foundation Collection.

Photograph. Reading Room at the 135th Street Library, ca. 1930. Schomburg Center for Research in Black Culture, Art and Artifacts Division, The New York Public Library. Jacob Lawrence spent many hours doing research for his history series paintings. National Archives, Harmon Foundation Collection.

The Photographer, 1942. Watercolor, gouache, and pencil on paper, 22 × 29½ in. The Metropolitan Museum of Art, New York. Purchase, Lila Acheson Wallace Gift, 2001. (2001.205).

Photograph. Jacob Lawrence lecturing on his art at Lincoln School, New Rochelle, New York, on February 28, 1941. Ray Garner, National Archives.

From *The Life of Harriet Tubman*, 1940. Casein tempera on hardboard, 12 × 17⅞ in. or 17⅞ × 12 in. Gift of the Harmon Foundation, Hampton University Museum, Hampton, Virginia:

Panel 1. "With sweat and toil and ignorance he consumes his life, to pour the earnings into channels from which he does not drink. —Harriet Ward Beecher."

Panel 18. "At one time during Harriet Tubman's expeditions into the South, the pursuit after her was very close and vigorous. The woods were scoured in all directions, and every person was stopped and asked: 'Have you seen Harriet Tubman?'"

Panel 23. "The hounds are baying on my track, / Old master comes behind, / Resolved that he will bring me back, / Before I cross the line."

Panel 9. "Harriet Tubman dreamt of freedom ('Arise! Flee for your life!'), and in the visions of the night she saw the horsemen coming. Beckoning hands were ever motioning her to come, and she seemed to see a line dividing the land of slavery from the land of freedom."

Panel 26. "In 1861, the first gun was fired on Fort Sumter, and the war of the Rebellion was on."

Panel 7. "Harriet Tubman worked as a water girl to field hands. She also worked at plowing, carting, and hauling logs."

Panel 11. "'$500 Reward!' Runaway from subscriber on Thursday night, the 4th inst., from the neighborhood of Cambridge, my negro girl, Harriet, sometimes called Minty. Is dark chestnut color, rather stout build, but bright and handsome. Speaks rather deep and has a scar over the left temple. She wore a brown plaid shawl. I will give the above reward captured outside the county, and $300 if captured inside the county, in either case to be lodged in the Cambridge, Maryland, jail./ (Signed) George Carter/ Broadacres, near Cambridge, Maryland,/ September 24th, 1849."

Panel 6. "Harriet heard the shrieks and cries of women who were being flogged in the Negro quarter. She listened to their groaned-out prayer, 'Oh Lord, have mercy.'"

Panel 28. "Harriet Tubman went into the South and gained the confidence of the slaves by her cheerful words and sacred hymns. She obtained from them valuable information."

Panel 5. "She felt the sting of slavery when as a young girl she was struck on the head with an iron bar by an enraged overseer."

Panel 21. "Every antislavery convention held within 500 miles of Harriet Tubman found her at the meeting. She spoke in words that brought tears to the eyes and sorrow to the hearts of all who heard her speak of the suffering of her people."

From *The Migration of the Negro*, 1941. Casein tempera on
hardwood, 12 × 18 in. or 18 × 12 in. The Phillips Collection,
Washington, D.C. (odd-numbered panels) and The Museum
of Modern Art, New York. Gift of Mrs. David M. Levy, 1942
(even-numbered panels):

Panel 3. "In every town Negroes were leaving by the hun-
dreds to go North and enter into Northern industry."

Panel 9. "Another great ravager of the crops was the boll
weevil."

Panel 52. "One of the largest race riots occurred in East
St. Louis."

Panel 22. "Another of the social causes of the migrants' leav-
ing was that at times they did not feel safe, or it was not the
best thing to be found on the streets late at night. They were
arrested on the slightest provocation."

Panel 51. "In many cities in the North where the Negroes had
been overcrowded in their own living quarters they attempted
to spread out. This resulted in many of the race riots and the
bombing of Negro homes."

Panel 57. "The female worker was also one of the last groups
to leave the South."

Panel 13. "Due to the South's losing so much of its labor, the
crops were left to dry and spoil."

Panel 46. "Industries attempted to board their labor in quar-
ters that were oftentimes very unhealthy. Labor camps were
numerous."

Panel 59. "In the North the Negro had freedom to vote."

Panel 16. "Although the Negro was used to lynching, he
found this an opportune time for him to leave where one
had occurred."

Panel 54. "One of the main forms of social and recreational
activities in which the migrants indulged occurred in the
church."

Selected Bibliography

Dow, Arthur W. *Composition. A Series of Exercises in Art Structure for the Use of Students and Teachers.* 1920. Reprint. Berkeley: The University of California Press, 1997.

Harper, Michael S., and Anthony Walton. *The Vintage Book of African American Poetry.* New York: Vintage Books, 2000.

Lewis, David Levering. *The Portable Harlem Renaissance Reader.* New York: Penguin Group, 1995.

Nesbett, Peter, and Michelle DuBois. *Over the Line: The Art and Life of Jacob Lawrence.* Seattle and London: University of Washington Press, 2000.

Nesbett, Peter, and Michelle DuBois. *Jacob Lawrence: Paintings, Drawings, and Murals (1935–1999). A Catalogue Raisonné.* Seattle and London: University of Washington Press, 2000.

Turner, Elizabeth Hutton. *Jacob Lawrence: The Migration Series.* Washington, D.C.: The Rappahannock Press in association with The Phillips Collection, 1993.

Turner, Elizabeth Hutton. *Georgia O'Keeffe: The Poetry of Things.* Washington, D.C.: The Phillips Collection and Yale University Press in association with the Dallas Museum of Art, 1999.

Wheat, Ellen. *Jacob Lawrence: The Frederick Douglass and Harriet Tubman Series of 1938–40.* Hampton, Virginia: Hampton University Museum in association with University of Washington Press, 1991.

Wheat, Ellen Harkins. *Jacob Lawrence: American Painter.* Seattle: University of Washington Press and Seattle Art Museum, 1986.

Jacob Lawrence. Interview by Elizabeth Hutton Turner for The Phillips Collection, Washington, D.C., 3 October 1992.

Jacob Lawrence. Interview by Jackson Frost for The Phillips Collection, Washington, D.C., 27–29 April 2000.

I'll Make Me a World. Blackside, Inc. in association with Thirteen/WNET, Boston, 1999 (www2.blackside.com/immaw/projectstage.htm).

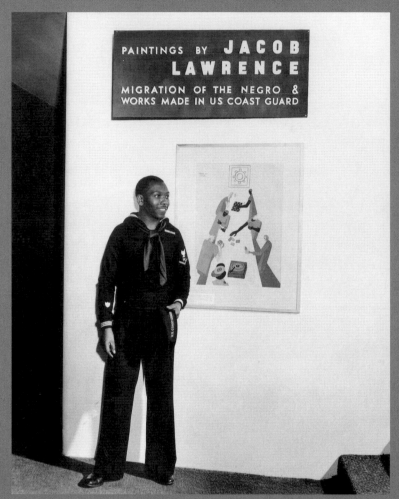

Jacob Lawrence at his solo exhibition at the Museum of Modern Art, 1944.